To: _____

From: _____

To Steve Bannos

Published by
Shake It! Books, LLC
P.O. Box 6565
Thousand Oaks, CA 91359
Toll Free (877) Shake It
www.*shake*that*brain*.com

This book is available at special discounts for bulk purchase for sales promotions, premiums, fund-raising and educational use. Special books, or book excerpts, can also be created to fit specific needs. Got a need? We'll try to fill it.

ISBN: 0-9667156-9-1
10 9 8 7 6 5 4 3 2 1

First Edition

Contents

Getting Into Things

Wild thing (I think I love you).
— Chip Taylor

Here comes the son.
Here to brighten your world...

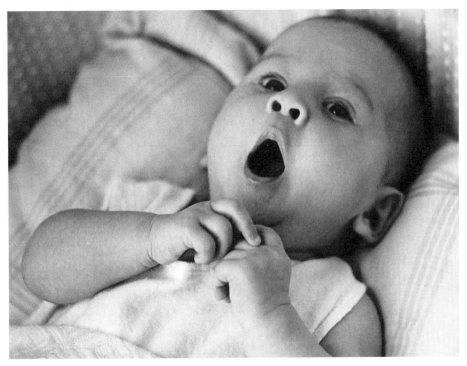

"So, what do you have planned for my life?"

And challenge your day.

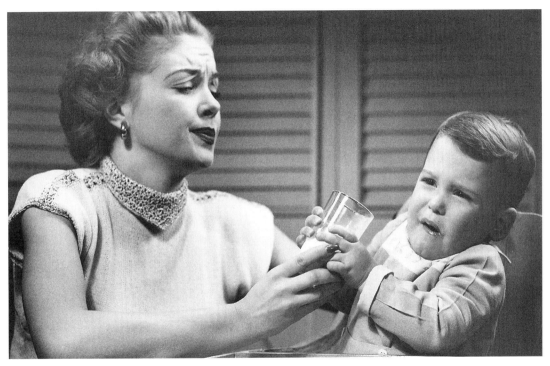

"Mom, I'm warning you. If I let this go, you're wearing it."

Sometimes he's a saint,
sometimes he's not.

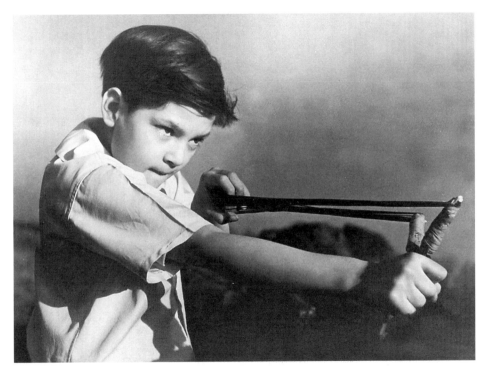

"Don't worry. I'll be careful."

Mostly, he's just busy being a boy,
getting into things and discovering their joy
—like a love for water he may never outgrow.

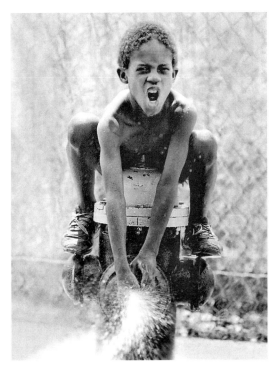

"There she blows!"

And a love for things and how they go.

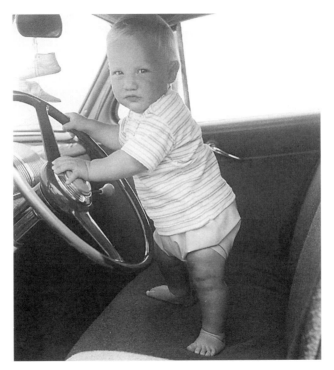

"Whaddaya mean I'm not old enough to drive?"

So when it comes time to bring out the cake
you can insist on nice and polite…

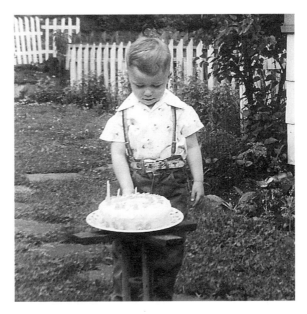

"Bless this cake… but I can't wait."

Or really let him have some fun!

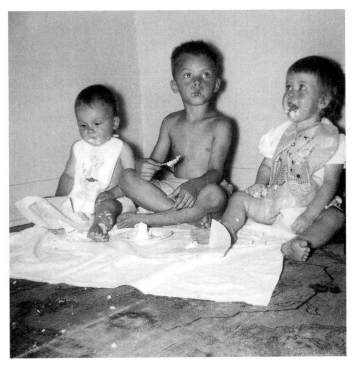

"See? We can have our cake and wear it too!"

Tip 1

Let him have fun.

Life will get serious soon enough.

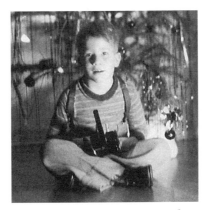

"I'm a kid. I'm supposed
to have fun."

Let him build to the sky, swing to the fence…

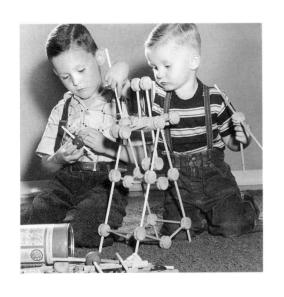

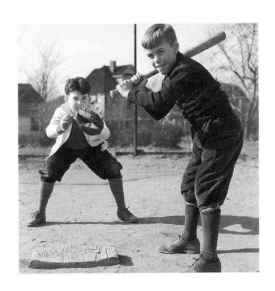

Swing a big pillow till he's ready to drop.

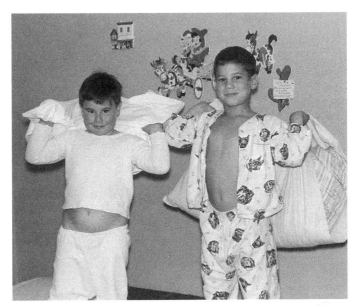

"Bedtime? Not in our lifetime."

And let him ride high with each new success.

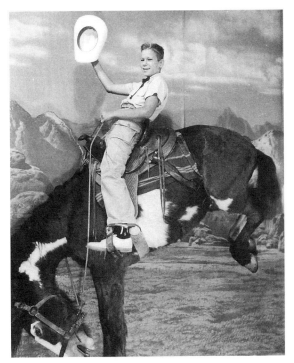

"Look, Ma! Top of the world!"

When he needs your help, be sure to lend a hand.
So he can do battle along with his peers.

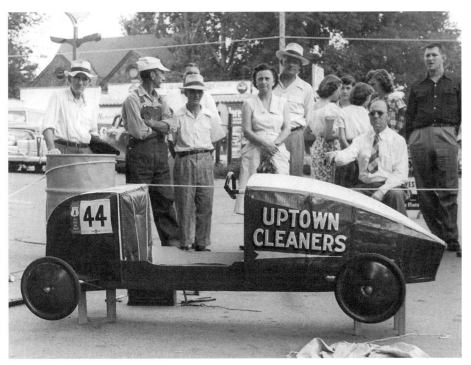

"Yep. She's a beaut."

And be sure to be there to cheer him along.

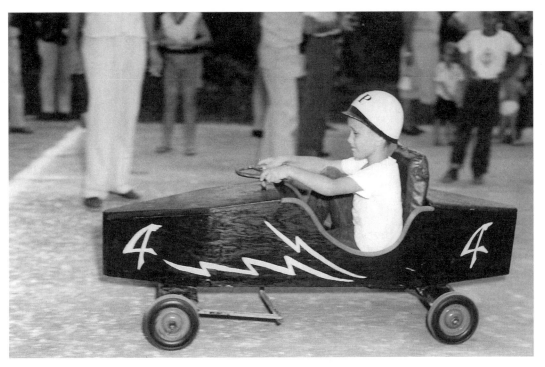

"Hold that trophy. *I need to make a pit stop.*"

Tip 2

Find the time.

He'll be grown before you know it.
Enjoy him while you can.

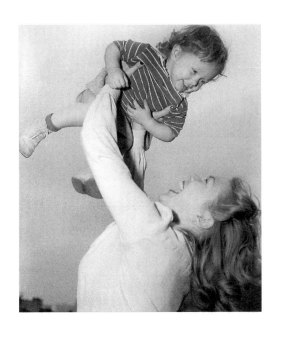

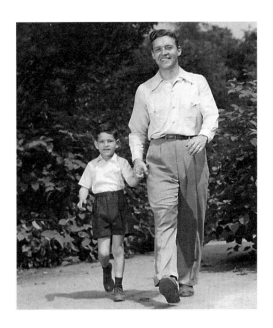

Take him camping now and then,
even if you start in your own backyard, singing:

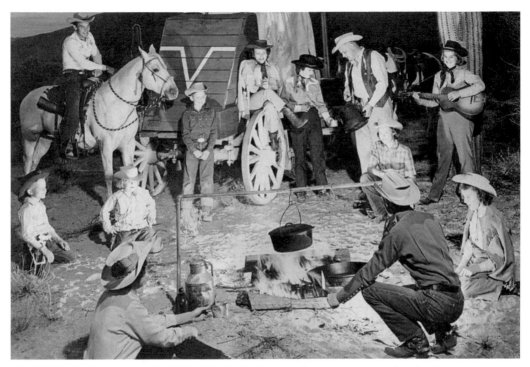

"I'm an old cowhand… and a camping fan!"

And while you're out there, teach him well.
Like how to catch dinner...

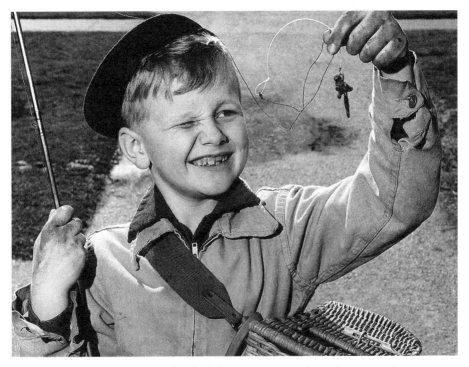

"Sure doesn't look like a Happy Meal to me!"

Or catch himself a hat.

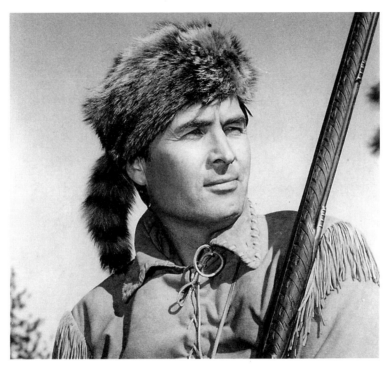

"That's right, son—with my own bare hands."

And when you take him to the game,
be sure to get there early.

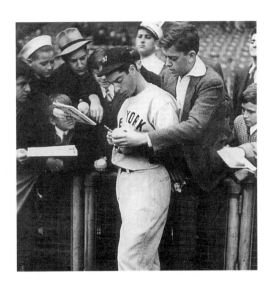

He might just meet someone bigger than life.

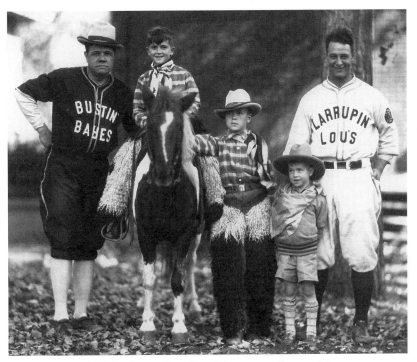

"This is a day I will never forget!"

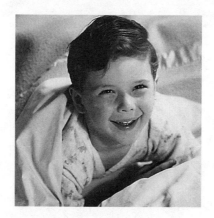

Now just try to get him to sleep.

Moving Out of Things

Call me irresponsible.
—Sammy Cahn and James Van Heusen

Blame it on my youth.
—Edward Heyman and Oscar Levant

You're raising him well.
He looks up to you still…

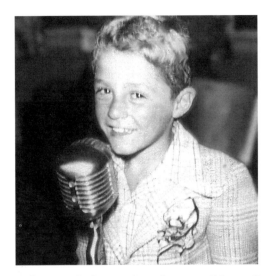

"This is dedicated to the one I love."

Even as he starts to chart his own style.

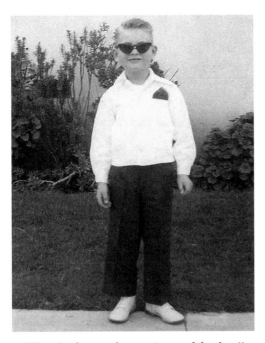

"Here's the cool, continental look..."

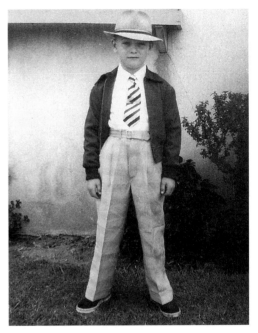

"And just the thing for days at the track."

Though deep down inside he still can't decide…

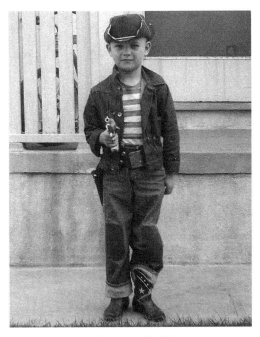

"Desperado?"

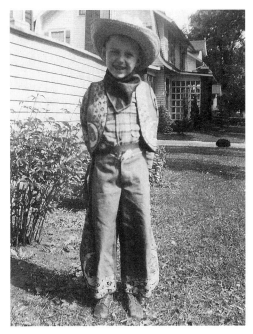

"Or desperately cute?"

Now along the way he'll make some mistakes.
(That's only natural.)
Breaking a window… Getting into a fight…

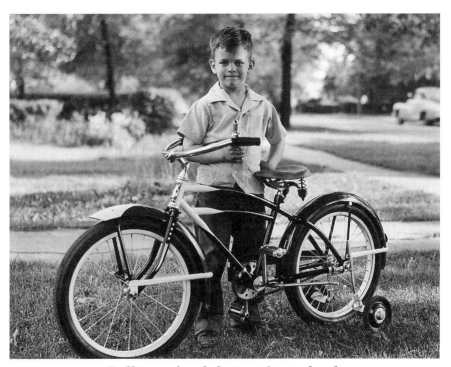

Pulling a bank heist after school.

Tip 3

Let him know, "Mistakes are okay."

*And tell him about mistakes you made as a child
— so he'll understand that making mistakes
is part of growing up.*

"And that's what happened when I left my bike in the street."

Meanwhile, he's working hard to sort out his world.
Like whether he loves that first day of school…

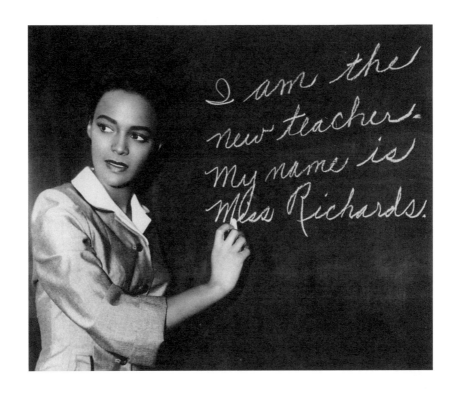

Or just can't handle learning more rules.

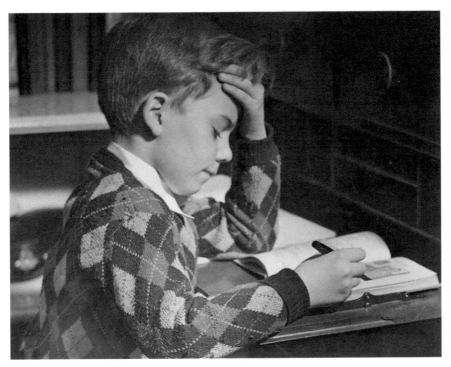

"Great, now I've got a migraine."

Whether life is still such fun,
or just a chore he's forced to endure.

"Boy, this is fun!"

"That's what I used to think."

And more and more, you find that telling him to do something and *getting him to do it* can be two different things.

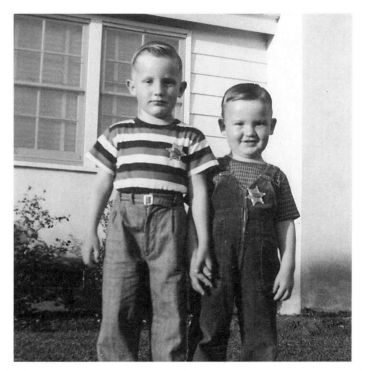

"We're sworn to serve and protect—not clean up."

Tip 4

Make it a contest.

Got a boy who won't pick up his things or get ready for bed? Make it a contest and you'll both be rewarded.

"Bet you can't get dressed
in two minutes."

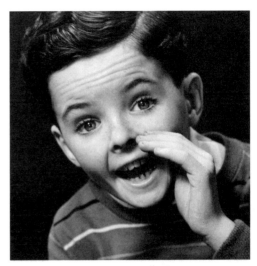

"Someone say 'bet'?
You're on!"

Of course, there are larger issues looming
—like whether it's still cool
to be seen with mom and dad...

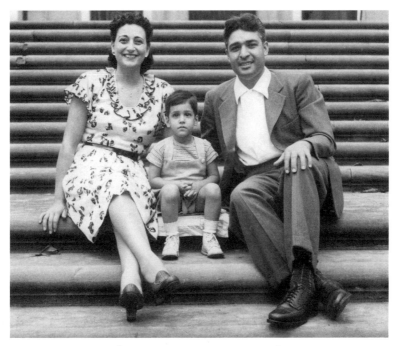

"I hope you're enjoying this.
Days like this will soon be passé."

Or maybe it's better to be hanging with the boys.

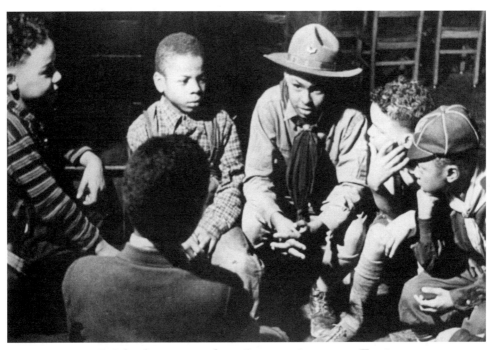

"I felt that way when I was nine, too, Ernie.
But now I'm ten and I've got some perspective on it."

He also starts spending more time away.
Maybe out back...

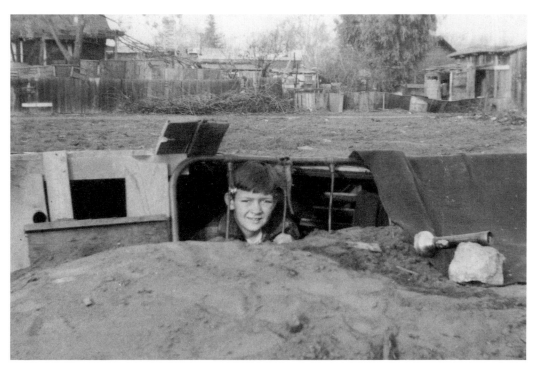

"Whaddaya think? My first apartment!"

Downstairs…

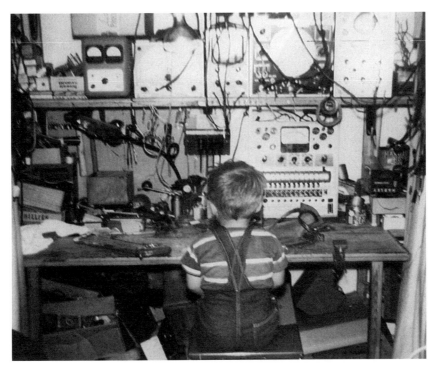

"Let's see... Cure cancer or blow up the house?"

Up in the bathroom…

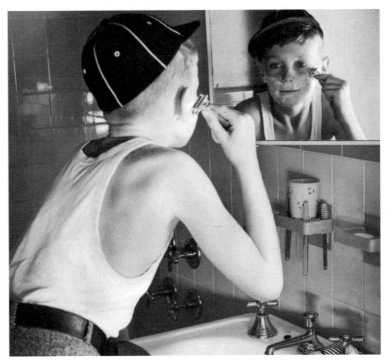

"Five o'clock shadow? It's not even noon."

Or up in his room, lost among his treasures.

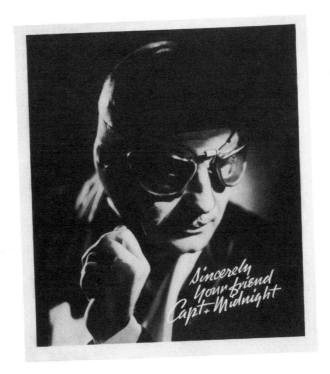

"Please do not touch. It's one of a kind."

Though truth be told, he'd give it all up
if someone could just explain…

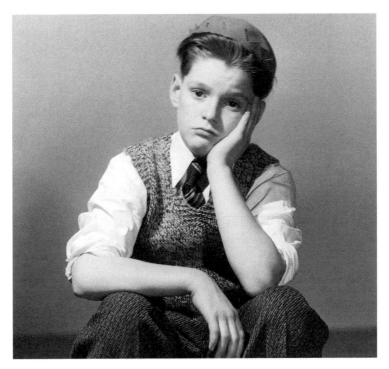

"What's with girls?"

What makes 'em tick?
How come they're always telling secrets?

"Just pretend I'm telling you something. It drives 'em nuts!"

And why can't it be…

"Like it used to be!"

"Would that be asking
for so very much?"

Spreading His Wings

See you later, alligator.
—Bobby Charles

I'm a man.
—Spencer Davis Group

There was a time (not so long ago)
that life with the boy was close to perfect.
He loved his mom, dad was a hero…

And nothing was better than time with the family.

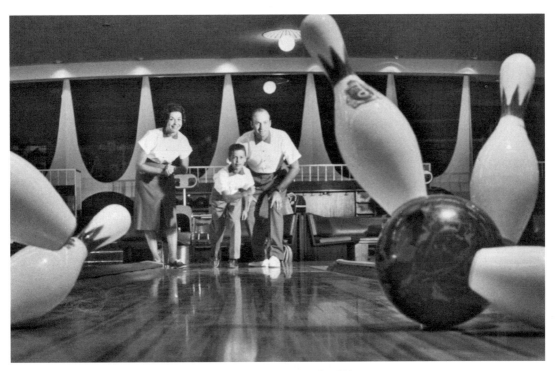

"Look, no gutter ball!"

But time marches on and so does the boy,
moving on to more responsibility…

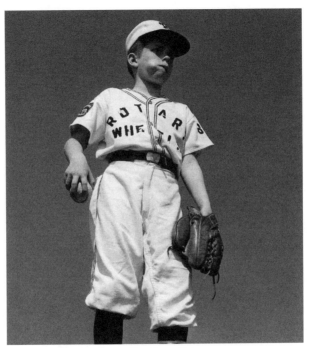

"Let's see. Strike this guy out,
hope he doesn't cry…"

And more risk.

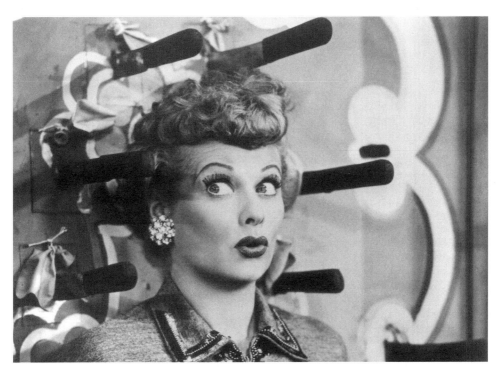

"C'mon, mom. Just stand still."

Maybe even a brush with the law.

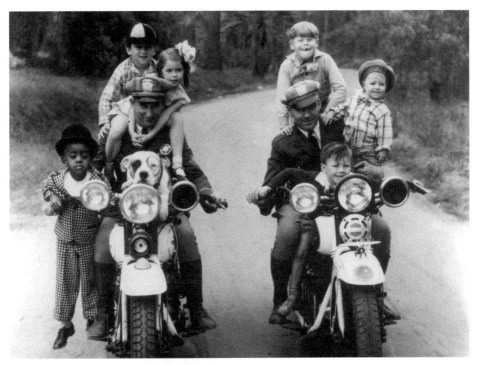

"We've been bad… but we're still having fun!"

He also starts spending more time with the boys.

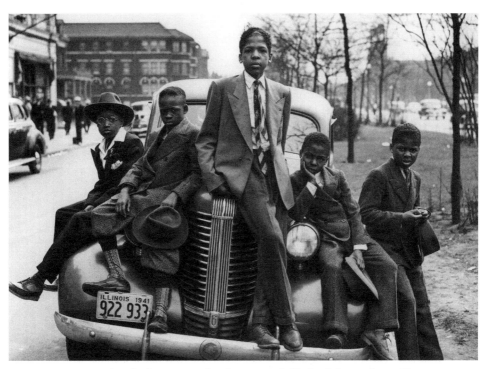

"…And that concludes our fall fashion show."

They're cool, they understand him,
but mostly they're clueless.
(Now it's a *group* of clueless.)

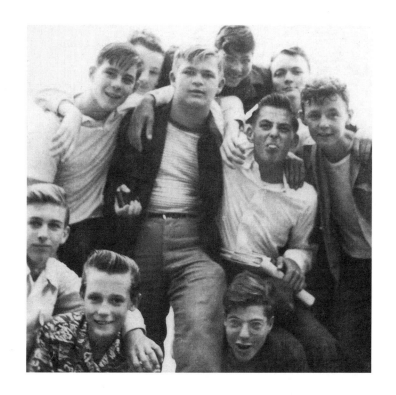

There are times, in fact, when you feel like shouting…

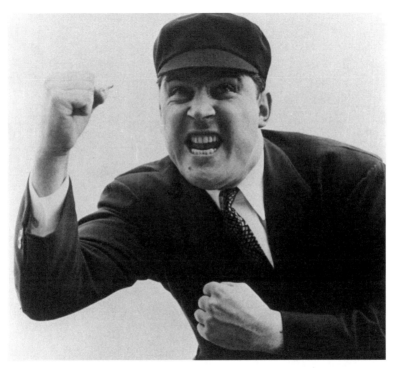

"You're out. Grounded. No leaving your room till you're 50!"

Tip 5

Find him a mentor.
(Or two.)

He needs someone to show him the ropes and guide him toward manhood.

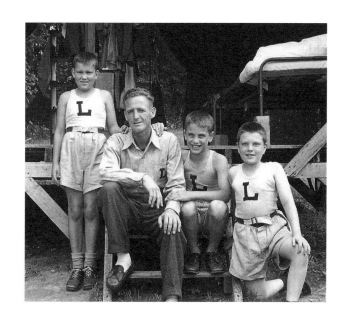

And as much as mom may want to lead the charge…

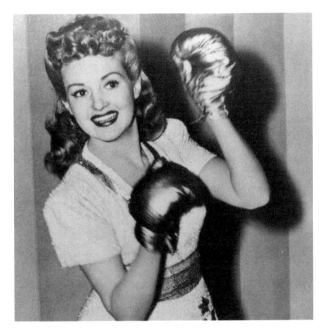

"C'mon, boys. Boxing's fun!"

A boy needs his time away from the nest.

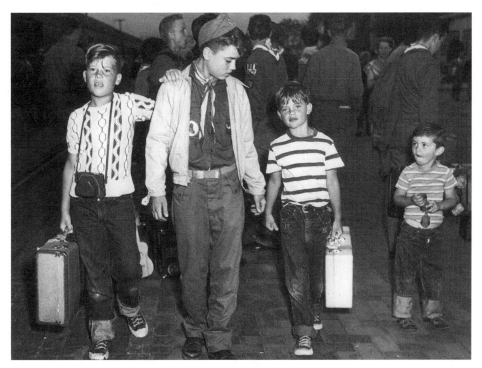

"Don't worry, guys. I'll be back."

But that's not to say your job's all done.
A parent's wisdom will always serve him well.

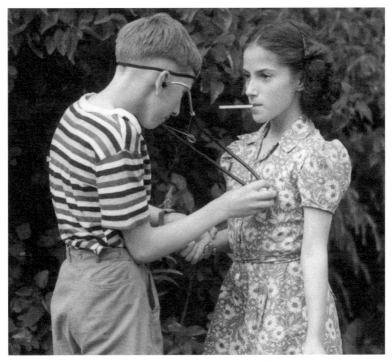

"Of course it's okay. I'm a doctor."

Boys will be boys, no matter what,
testing their limits and testing yours.

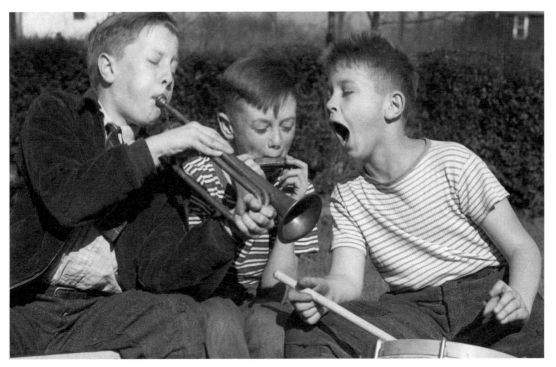

"Born to be wi-i-i-i-ld!… Born to be wi-i-i-i-ld!"

And no matter how old he really is...
he's still your little boy.

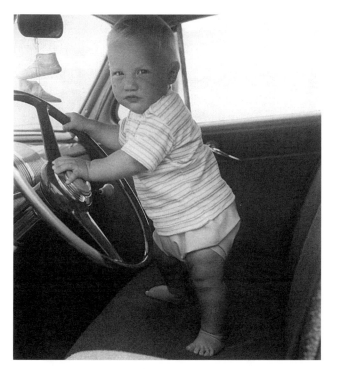

"I'm 17. I know how to drive."

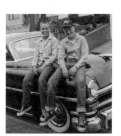

"Anyone know where we can find some girls?"

So teach him well... then let him go.

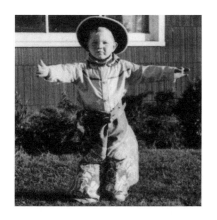

And know he'll move on when it's time to grow.

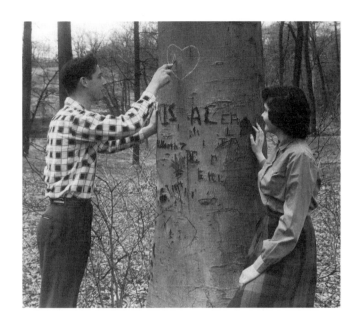

And that's how you raise…

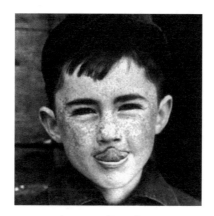

A very fine boy.

Also available in the "Picture Books for Grown Ups" series...

Fairy Tales Can Come True

(Just not every day!)

J.S. Salt

How to keep the love in your love life

A Picture Book
for Grown-Ups

More fun for couples from Shake It! Books...

Compiled by J.S. Salt

"Shocking.
Simple.
Profound...
provocative."
Dallas Morning News

Compiled by J.S. Salt

www.**shake**that**brain**.com

For books with a sense of purpose... and a sense of humor.

And coming in 2002...

Thank Heaven for Little Girls

(Most of the time!)

Because *Boys Will Be Boys* deserves a great "sister" book.